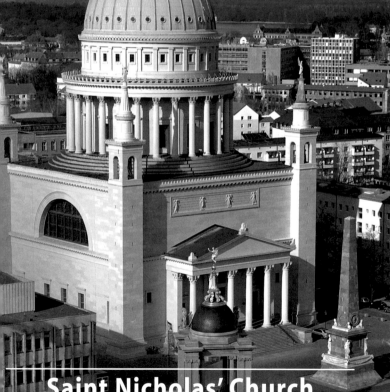

Saint Nicholas' Church
Potsdam

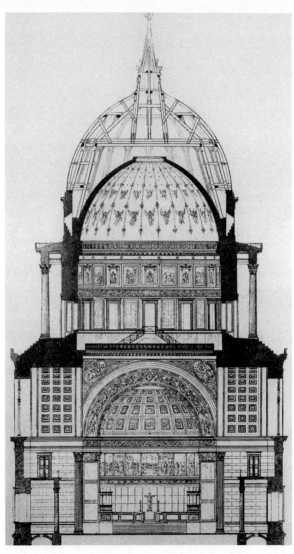

▲ *Cross section, drawing, K. F. Schinkel, 1829*

Saint Nicholas' Church, Potsdam

by Andreas Kitschke

Introduction

Saint Nicholas' Church and its typical dome atop a drum dominate the north bank of the Havel River and the entire centre of Potsdam, the capital city of the Federal State of Brandenburg. The building's magnificent Corinthian colonnade is visible from afar within Potsdam's skyline. The attic storey with windows framed by Ionic pilasters rests on the columns' capitals adorned with palmettes. It supports the majestic dome topped with a lantern and a conical structure upon which rest an orb and a golden cross at a height of seventy-seven metres above the ground.

The colonnade at a height of forty-two metres has been open to the public since 2010. From here, visitors enjoy a wonderful panorama over the many hills and lakes of the Havel region, as well as the building sites of the reviving city centre; in particular those of the new regional parliament being built in the shape of the former royal palace.

Saint Nicholas was re-consecrated as Potsdam's main Protestant church in 1981. It is now an important location for religious and cultural gatherings such as regular parish services, occasional supraregional services, church music concerts, exhibitions and lectures.

Castle, Town and Church

A document from 993 bearing the seal of Emperor Otto III (980–1002) mentions a Slavic circular fort named "Poztupimi" that stood near the confluence of the Havel and Nuthe Rivers. The fort was abandoned at the beginning of the 13th century, while a small castle was built around 1220 southeast of today's Neuer Markt square, as assumed by historian Helmut Assing. A new castle made of stone was built around 1320 southeast of the old structure, near a ford in the Havel River, at a location where a ferry was installed in 1375 and a

bridge built in 1416. (The bridge was rebuilt several times, today's structure being called "Lange Brücke".)

A document from 1317 mentions the castle under the name "oppidum Potstamp". The Lehnin Monastery was the first landlord. In 1323, Duke *Rudolf II of Saxony-Wittenberg* (1307–1370) sold the castle and the eyot on which it stood together with various villages (Nedlitz, Bornstedt, Golm, Grube, Bornim and Eiche) to the chapter of Brandenburg's Cathedral. However, it is unclear whether the transaction was ever valid. In 1345, Margrave *Louis the Bavarian* (1315–1361) declared that he would never mortgage "[his] city of Potsdam" (*civitatis nostre Postam*) but maintain the charter that already existed. The 1375 cartulary of *Emperor Charles IV* (1316–1378) lists the town and its "accessories", including the castle and three fishermen villages. The town was finally mortgaged in 1400. *Frederick VI of Nuremberg* (1371–1440), a burgrave of the House of Hohenzollern, was appointed hereditary administrator of the Margraviat of Brandenburg in 1411, thus establishing the rule of his dynasty over the entire territory around Potsdam. Four years later, Emperor *Sigismund* (1368–1437) appointed the burgrave Elector of Brandenburg and Great Chamberlain under the name Frederick I. On 28 February 1416, the population of Potsdam paid homage to the new ruler, who in turn confirmed their charter and authorised the construction of the above-mentioned bridge over the Havel River. After a fire had destroyed the castle in the late 15th century, Elector *Joachim I* (1454–1535) had a circular stronghold built in 1528 near the bridge. The dwelling that stood in the court was to become Potsdam's royal palace, as structure later remodelled in the Baroque style by *Georg Wenzeslaus von Knobelsdorff* (1699–1753) that was ultimately guttered by fire in 1945 and demolished in 1960.

An entry made in a Bologna University register on 24 February 1314 mentions for the first time a clergyman from Potsdam named Friedrich, who was in the retinue of the nobleman Martin von Krokere (or von Kröcher). In the Middle Ages, the Holy Mass was celebrated several times a day on the various altars of Potsdam's church, while donations for the poor against indulgences were frequent. In a document dated 16 September 1476, for example, *Arnold von Burgsdorf*

(† 1485), Bishop of Brandenburg, provided a 14-day indulgence to those participating in the daily "Salve Regina" procession donated by Hans Heyns, a citizen of Potsdam. Among the villages surrounding the town, only Bornim and Golm had a church in the early Middle Ages, so people living the other villages regularly came to Potsdam for mass.

In 1724–26, the Church of the Holy Spirit (Heilig Geist) was built to plans by *Pierre de Gayette* (1680/81–1747) on the site where the Slavic fort used to stand. Two years later, *Johann Friedrich Grael* (1707–1740) complemented the elongated building with an impressive, 87-metre-high tower. After the destruction of the church in 1945, the parish of the Holy Spirit merged with the St. Nicholas and the Teltow Neighbourhood parishes in 1981. The Heilig-Geist-Park senior residence built recently by Venetian architect *Augusto Romano Burelli* (born 1938) takes over the former church's volume, however.

First Parish Church

The Bishoprics of Brandenburg and Havelberg established in 948 organised the Christianisation of the pagan Slavs living in the Northern March. In the 13th century, the Cistercian monks of Lehnin Monastery built a three-nave Romanesque basilica on the site of today's St. Nicholas' Church. The building was made of natural stones and had a rectangular tower to the west. It was probably dedicated to the Virgin Mary like the monastery's church, but medieval documents only mention "the parish church". Nonetheless, a dedication to Saint Nicholas is also possible, as a pond that belonged to the monks was named "Niklassee" (today's Platz der Einheit square).

In the mid-14th century, the Romanesque basilica was remodelled as a Gothic hall church. The choir and the two first bays were vaulted, while the five bays behind the pulpit kept their flat beam ceilings. Several chapel altars complemented the choir altar. A crypt existed under the church and a graveyard surrounded it. (The crucifix that adorns the Catholic St. Joseph's Chapel today is the sole work of art from the original parish church that still exists. In the Middle Ages, statues of St. John and the Virgin Mary probably complemented the crucifix.)

▲ *The elector's palace and the parish church, etching,*
P. Schenk, around 1700

In 1539, Elector *Joachim II* (1505–1571) converted to Lutheranism. A visit report dating from May 1541 indicates that the parish church had "fallen in a state of disrepair" by that time. Restoration works were performed in 1544 and the tower roof renewed after a fire in 1563.

In 1591, Hans and Heinrich von Lindenau, who lived in nearby Saarmund Castle, donated a triptych kept in the Renaissance style. The Virgin and Child on the central panel still reflected the Catholic tradition and indicated that the original parish church should have been dedicated to the Virgin Mary. However, the sacral building was named "St. Catherine's Church" shortly after the death of Catherine of Brandenburg-Küstrin (1549–1602) in honour of the princess's numerous donations.

A new font was first used on 3 September 1682 on the occasion of the baptism of "Andreas Becker, a child of Sweden". The pulpit rested on a stone pedestal and was adorned with portraits of Jesus and the twelve Apostles.

As more space was needed inside the church in the late 17th century, a three-storey gallery was built in front of the pulpit. A new organ was acquired for three hundred thaler in 1714.

Baroque Church

Elector *Frederick William I* (1688–1740) installed a garrison in Potsdam in 1713, which boosted the growth of the city in the following three decades. On 7 April 1721, the "Sergeant King" ordered the demolition of the original church "because of the dilapidation of the building and growth of the parish". The king's order also provided for the transfer of the graveyard behind the Berlin Gate and the construction of a new, larger church. On 12 November 1724, the new Lutheran church was consecrated to Saint Nicholas with the king attending the ceremony.

The building's plans were works by *Philipp Gerlach* (1679–1748), who later also designed Potsdam's famous Garrison Church. *Pierre de Gayette* supervised the construction works. The new sacral building had a cruciform ground plan with a slender bell tower to the north

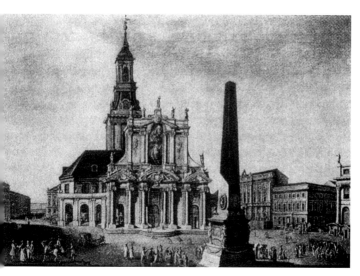

▲ *The Baroque church built to plans by Ph. Gerlach and provided with a monumental façade by G. W. von Knobelsdorff, painting, J. F. Meyer, 1771*

that rose as high as ninety-four metres. The transept with a T-shaped extension to the south was flanked by two-storey galleries that begirt an octagonal space extending in front of the altar and the pulpit made of oak.

The organ of the former church had been sold and the wood burned somewhere in the city. As Berlin's Garrison Church was in ruins after the explosion of the nearby powder magazine, the king had organ-builder *Joachim Wagner* (1690–1749) take the organ to pieces and rebuild it in Potsdam's Baroque church. A work by *Johann Michael Röder* (1670–1748) built in 1713, the new organ had twenty-three voices and was adorned with sophisticated moving figures: angels playing cymbals and beating drums "captured from the Swede after the famous battle of Fehrbellin"; eagles whose feathers were made of pipes and who seemed to be flying toward rotating suns.

King *Frederick the Great* (1712–1786) had the esplanade extending in front of the church ("Alter Markt") remodelled in the Italian style. In 1752/53, he commissioned *Georg Wenzeslaus von Knobelsdorff* with adorning the church's southern façade with a copy of the west front of Rome's Basilica St. Mary Major, a work by *Ferdinando Fuga* (1699–1782) built ten years before. The decoration of the new façade included sculptures, reliefs and an allegorical fresco by *Philippe van Loo* (1719–1795) figuring Christian virtues.

On 3 September 1795, shortly before the completion of extensive refurbishment works, a fire destroyed the Baroque St. Nicholas Church: a plumber working on the roof of the bell tower had left a fire used to solder unattended. The fire also destroyed seven houses and damaged twenty-four further structures; these were soon rebuilt however. The ruins of the church were demolished the following spring, except for Knobelsdorff's façade, which was not torn down until 1811.

Michael Philipp Boumann (1747–1803), head custodian of royal buildings, and *Friedrich Gilly* (1772–1800), a prodigy in architecture, designed plans for a new church but none of these projects were ever built due to the death of King *Frederick William II* (1744–1797) and the French occupation of Prussia in the following years.

Schinkel's Church

The parish of St. Nicholas remained without church for decades and even considered merging with other Potsdam parishes. But on 27 February 1826, *Frederic William III* (1770–1840) finally ordered the reconstruction of St. Nicholas' Church. The king had in mind a rectangular, three-nave hall church modelled on Paris' Saint-Philippe-du-Roule (a work by *Jean Chalgrin* built in 1772–84), but the crown prince favoured a compact structure topped with a drum and a dome. *Karl Friedrich Schinkel* (1781–1841), who had been working on the project since 1818, endeavoured to make a compromise and designed new plans that included some elements of Gilly's ideas revisited in the Neoclassical style.

Schinkel's design featured clear geometrical forms: a cube, a cylinder and a hemisphere. However, the crown prince insisted that the hemisphere be an ogive, which would make the dome appear much lighter. The architect took urban planning considerations into account and was inspired by noted works such as St. Peter's Basilica in Rome (built 1546–85 to plans by *Michelangelo Buonarroti*, 1475–1564), St. Paul's Cathedral in London (built 1664–1710 to plans by *Christopher*

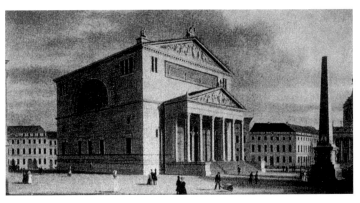

▲ *The church built to plans by Schinkel, painting, W. Barth, 1838*

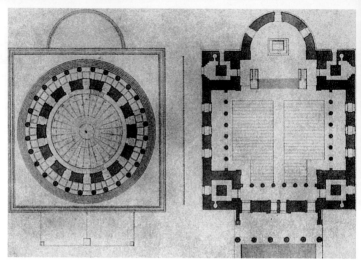

▲ *Ground plan of the church with its dome, drawing, K. F. Schinkel, 1834*

Wren, 1632–1723) and Paris' Panthéon (built 1764–91 by *Jacques-Germain Soufflot*, 1713–1780).

Schinkel added a Corinthian portico to the south and a semicircular apse to the north, and structured the cube's plaster façades kept in various sandstone shades with joints suggesting ashlars. Moreover, he provided the lateral sides with two large, semicircular Diocletian windows corresponding with the barrel vault with a span of nineteen metres.

The foundation stone of the new St. Nicholas' Church was laid on 3 September 1830, i.e. exactly thirty-five years after the destruction of the Baroque church by fire. *Ludwig Persius* (1803–1845) supervised the construction of the cube using bricks made in Brandenburg. According to the king's wishes, two bell towers were to flank the main façade, but the bells were finally installed in compartments positioned at the top of the four corners.

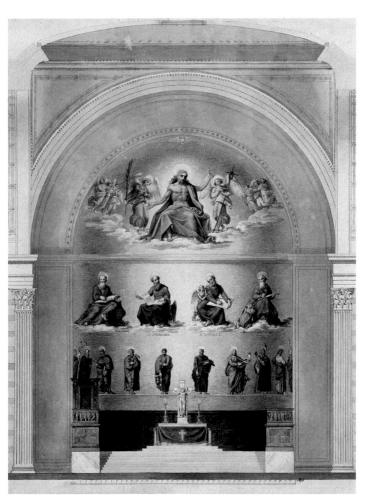

▲ *Sketch for the decoration of the apse, pencil, black ink and watercolour, 1834, cat. no. SM 24.a.18*

In 1833, after the removal of the interior scaffold, the apex of the barrel vaults subsided thirty centimetres on average and long vertical cracks appeared on the walls, which meant that topping the cube with a dome became impossible. A provisory solution consisted in covering the cube with a cupola and a saddle roof. Both tympanums were adorned with bas-reliefs by Schinkel, one figuring the *Ascension of Christ*, the other the *Sermon on the Mount*.

On 17 September 1837, Bishop *Daniel Neander* (1775–1869) consecrated the new St. Nicholas' Church with King Frederick William III attending the ceremony. The audience enjoyed an unrestricted view toward the choir almost regardless of their position in the church, but the sound reverberations with various decay times were a great problem.

Frederick William IV (1795–1861) was a talented artist who, as mentioned above, was involved in planning the building before his accession to the throne. In 1843, he ordered the construction of the ogival dome he had designed as crown prince, whereby the actual dome was to cover a smaller interior cupola. As Schinkel had died two years earlier, the king entrusted Persius with the complicated project. In order to reduce the load on the barrel vaults, the architect used diatomite bricks for the drum and light-weight conical clay elements for the self-supporting interior cupola. He also reinforced the barrel vaults, altered the pendentives, added circular anchors, replaced the bell compartments with turrets designed like buttresses and provided them with yoke-mounted bells. Furthermore, Persius adorned the turrets with two versions of the angel statue that Schinkel had created to top the lantern, and replaced the heavy dome timbering with a filigree iron structure delivered by Berlin locomotive manufacturer *August Borsig* (1804–1854).

After Persius' premature death in 1845, the king commissioned *August Stüler* (1800–1865) with completing the works and the church was consecrated again on Palm Sunday 1850 (24 March). By that time, the cross, the dome's ribs and ox-eyes, as well as the serrated top and the seven angels of the lantern were "painted with gold-yellow oil paint and their edges coated with gold leaf so that, despite their par-

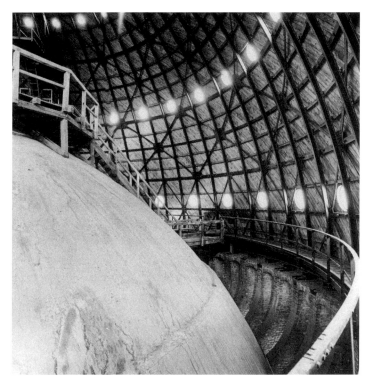

▲ *View between the cupola and the dome*

tial gilding, all these elements seemed to be entirely gilt". (Today only the top cross is gilt.)

Frederick William IV thus provided Potsdam with a landmark and enhanced the quality of the "three-church perspective" that ran from east to west from the Church of the Holy Spirit over the St. Nicholas' Church to the Garrison Church.

Oskar Hossfeld (1809–1881) supervised the remodelling of the interior decoration in the Neo-Renaissance style in 1912/13. On this occa-

sion, *Max Kutschmann* (1871–1943) created the ornaments while *Fritz Wichgraf* (1853–1939) restored the paintings.

Destruction and Reconstruction

Saint Nicholas' Church suffered only minor damages during the RAF raid over Potsdam on 14 April 1945: one single bomb perforated the dome; all the others glided over the curved surface. However, a few days later, the Soviet artillery caused severe damage as the Red Army attacked Potsdam from Brauhausberg Hill: the dome fell to pieces on the solid interior cupola that luckily did not collapse; the southwest turret was hit by a projectile and the topping tin figure was found later in the ruins, so it could be repaired and reused (the statue now has the same gesture as the angel next to it, however); after the portico collapsed, a shell went through the opening in the wall and set fire to the great organ; several drum columns were hit by various projectiles, making the entire upper part of the church dangerously unstable.

The first winter after the war was bitterly cold and the people used the pews and the stalls as firewood. In 1947, *Winfried Wendland* (1903–1998), head of Potsdam's Lutheran Church building office, initiated the first consolidation measures: the ruins of the dome were removed, the cupola was made watertight to serve as a provisional roof and the drum columns were consolidated with bricks as sandstone was not available. Due to the shortage of building materials, people smuggled cement on trains across the demarcation line with West-Berlin (!) and repaired a circular anchor with iron taken from the ruins of the Holy Spirit Church.

The dome was rebuilt to the original but with a steel filigree structure in 1956–59, and the lantern with the orb and the cross was finished on 28 August 1962. The exterior of the church thus regained its original state, except for the tin palmettes that had been looted as the metal was highly valued on the black market.

Nonetheless, St. Nicholas' Church remained unusable. As the rectory standing east of the building was also in ruins, for many years the

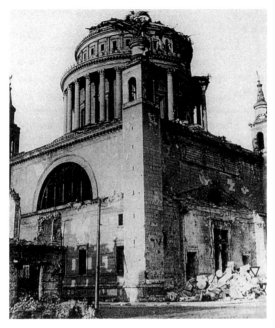

▲ *Ruins of St. Nicholas' Church, photograph, 1946*

parish used the church-hall built in 1909 in a nearby street. (Upon the re-consecration of the church in 1981, the parish transferred its property rights on the hall to Potsdam City Council; the building kept its original name, "Nikolaisaal", and has been used as the city's concert hall since 2000.)

Architect *Horst Göbel* radically altered the interior. Behind the lateral galleries, he created two-storey administration rooms, separated from the church proper by dark glass partition walls so that the interior could no longer benefit from the natural light coming through the large Diocletian windows. Göbel also created additional rooms in the basement and improved the acoustics using perforated, fairly unaes-

thetic plates affixed on the barrel vaults and below the drum. The original colourful paintings from 1912/13, however, were in such a poor condition that they could not be restored and had to give way to a more reserved decoration. Finally, Göbel closed the opaion (opening in the cupola) and provided the Diocletian windows with glass in the colours of the rainbow according to Schinkel's design.

The reconstruction of St. Nicholas' Church was possible thanks to funding from the East German government and Lutheran Church (in particular the Otto Nuschke Culture Foundation named after a former chairman of the East German Christian Democratic Union). West-German taxpayers also contributed nine million German marks through a "special reconstruction programme" financed using the church rate. Reconstruction started in 1967. After long periods of interruption, the works were finally completed in the "Schinkel Year" 1981, and the church was re-consecrated on 2 May.

Refurbishment of the Exterior (2002–2010)

The east façade and its two turrets were entirely refurbished in early 2002. Between August 2006 and July 2010, Potsdam architect *Bernd Redlich* and site engineer *Ivo Dressler* carefully completed the refurbishment of the exterior and mastered the many technical challenges of the job. Analysis of the diatomite bricks revealed that the material only marginally contributed towards reducing the load on the two barrel vaults; Persius had merely achieved the load reduction by placing four hollow columns between each of the three massive ones facing the turrets. The staircase in the northwest turret providing access to the colonnade, which was built by Schinkel but bricked up in 1843, was reopened. After lowering the level of the esplanade extending in front of the church ("Alter Markt"), it was necessary to complement the flight of stairs in front of the portico, thus returning the ensemble to its original dimensions.

The refurbishment of the dome included dismantling the lantern and replacing its corroded steel structure. As workers removed the top cross to have it gilt, they found a copper casket inside containing

building documents and a list compiled by the church council in 1962 with names of church employees jailed by the East German government. The casket was soldered shut again later on. On 31 October 2006 (Reformation Day), Bishop *Dr Wolfgang Huber* and Minister-President *Matthias Platzeck* replaced it in the gilt cross together with another casket containing new documents.

The cladding made of cement and reinforced concrete that was applied in the 1970s caused severe damage to the façades. As the 19th-century cladding made of brick and hydraulic lime plaster had partially survived on the north façade, it was possible to restore the exterior to its original state. The drum regained its distinctive sash windows (originally cast iron, now made of steel) and the base of the dome received a new copper plating. The palmettes adorning the entablature and the base of the dome were re-created as they had been omitted in 1981. The four columns damaged during the war and provisionally restored with bricks were re-plastered in a conical shape and made to resemble their sandstone counterparts. The cast-zinc angels on the bell towers received a new stainless steel brace and a special coating to give them the appearance of sandstone figures. Only one section of the Diocletian window facing the west regained its vivid original colouring as there was not enough funding to restore it entirely for the time being. The removal of the metal cladding on the stone steps between the cube and the drum helped recreate the unity between both volumes.

As mentioned above, Schinkel had structured the cube's plaster façades with a total area of some 11,000 square meters (i.e. more than two football pitches) with joints suggesting ashlars. The author of the present brochure provided written proof that the original façades were kept in various sandstone shades, while restorer *Gottfried Grafe* discovered remains of the 19th-century colours beneath the colonnade. Following lengthy negotiations with the monument protection authorities, architect *Bernd Redlich* received the go-ahead to redo the façade in three sandstone shades, which improved the building's overall appearance considerably.

Southeast turret with prayer bell ▶

The eight-million euro restoration project was funded by the Federal Government, the State of Brandenburg and the City of Potsdam, as well as by the local and regional church authorities (*Kirchenkreis Potsdam* and *Evangelische Kirche Berlin-Brandenburg-schlesische Oberlausitz*). However, the church had to take out a loan to the tune of approximately two million euros, which it will be repaying for decades to come.

The Bells

The four original corner compartments had shutter openings, although only the two front ones were provided with bells. The flat, bowl-shaped metal instruments struck with clappers used to produce an 'unpleasant' sound, but the situation improved with the construction of four 45-metre-high turrets provided with bronze bells cast in 1849 by *Johann Carl Hackenschmidt* (1778–1858). Three of them were requisitioned in 1917 to produce armaments, while the fourth and smallest one was thrown to the ground and the debris sold off as scrap metal by unknown individuals in 1945.

In the post-war period, the parish used two cast iron bells dating from 1922 and a bronze one cast in 1950 for the damaged Garrison Church that was acquired before the demolition of the building.

A melodious peel of four bronze bells rang out for the first time again at Easter 2010. Donated by the Prussian Cultural Heritage Foundation, the bells with the strike notes D' (Ø 140 cm / 1.7 t), F' (Ø 110 cm / 1.1 t), G' (Ø 107 cm / 0.8 t) and A' (Ø 98 cm / 0.6 t) were cast at the Mark Maas bell foundry in Brockscheid/Eifel in 2009. Their pitches and the inscriptions they bear have symbolic meanings: ringing the deepest bell reminds us that thanksgiving is the keynote of life: "GIVE THANKS UNTO THE LORD, FOR HE IS GOOD" (thanksgiving bell); the second bell cries: "FORGIVE US OUR TRESPASSES" (the Lord's bell); the third urges: "PRAY WITHOUT CEASING" (prayer bell); and the fourth rings out exultantly: "PRAISE THE LORD" (bell of praise).

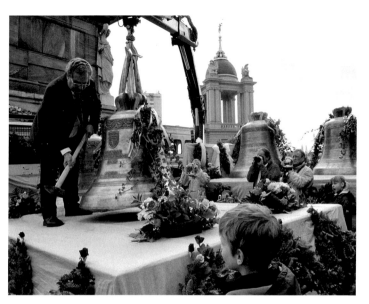

▲ *Ceremony on 20 March 2010 to mark the installation of the new bells*

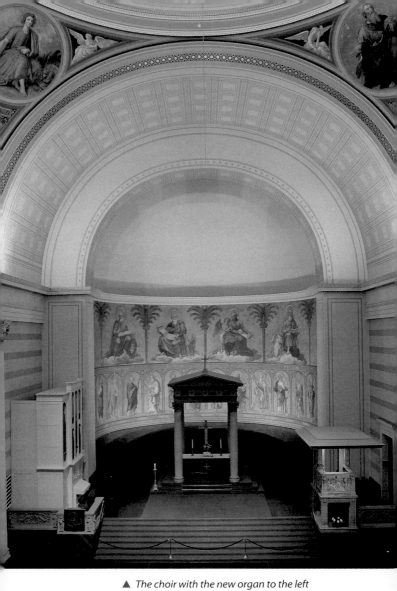

▲ *The choir with the new organ to the left*

Interior Decoration

The cube's ground plan has the shape of a Greek cross inside, the four re-entrant corners with staircases and sacristies supporting the barrel vaults. The use of pendentives to absorb the dome's load made columns superfluous, enabling the congregation to enjoy an unrestricted view of the altar and pulpit. The apex of the dome is fifty-two metres above the ground. (The neighbouring seventeen-storey high-rise hotel is only one metre taller.) A circular gallery with a classic-style rosette balustrade runs above the pendentives at a height of thirty-one metres.

The decoration of the church's substructure (ashlars and ochre-coloured coffering on the north and south barrel vaults) roughly adopts Schinkel's design from 1837. However, the interior lost its original vastness in 1981 after the construction of galleries provided with dark partition walls in three limbs of the cross in 1981.

The main pieces of the liturgical furniture are works by Schinkel that survived the war. The block-like altar and the font are made of black Bohemian marble with gold ornaments. The ciborium resting on four Corinthian columns made of yellow Veronese marble is a work by August Stüler that Frederick William IV ordered in 1850. The king also commissioned *Christian Friedrich Tieck* (1776–1851) with creating the freestanding marble cross with a relief portrait of Christ that stands under the ciborium. Both works underscore the importance of the freestanding altar, but partially conceal the wall painting that adorns the apse.

The pulpit features an oversized abat-voix from 1913 and three zinc bas-reliefs cast by *August Kiss* (1802–1865) after designs by Schinkel. They figure the *Sermon on the Mount, Jesus in the Garden of Gethsemane* and the *Resurrection*. Both the pulpit and the font bear inscriptions from the Beatitudes: "BLESSED RATHER ARE THOSE WHO HEAR THE WORD OF GOD AND KEEP IT" (Luke 11:18) and "WHOEVER BELIEVES AND IS BAPTISED WILL BE SAVED, BUT WHOEVER DOES NOT BELIEVE WILL BE CONDEMNED" (Mark 16:16). As the Lord is physically present when the congregation partake of the Lord's Sup-

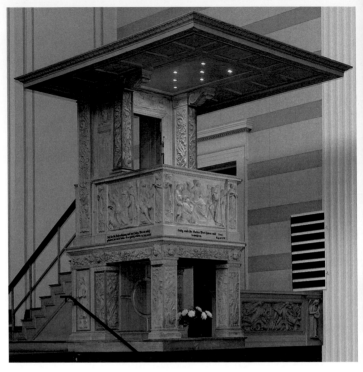

▲ *Pulpit*

per, no inscription is required on the altar, which is thus the only piece of liturgical furniture without a quote from the Beatitudes.

The light, airy wall painting in the apse is a work by *Bernhard Wilhelm Rosendahl* (1804–1846) based on designs by Schinkel. On two rows, it figures the four Evangelists with their attributes as well as twelve Apostles. Ossowsky and Lompeck added the arches and palms in 1849. The Evangelists appear in a different order than in the New Testament — from left to right: Mark (lion), Matthew (angel), John

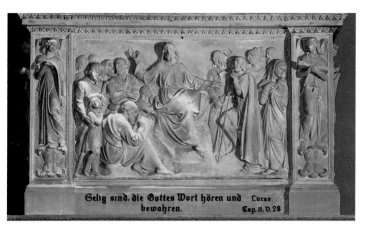

Selig sind, die Gottes Wort hören und bewahren. Lucas Cap. 11. V. 28

▲ *Bas-relief on the pulpit figuring the Sermon on the Mount, zinc, A. Kiss, after a design by K. F. Schinkel*

(eagle) and Luke (bull). The Apostles Judas Iscariot and James the Less are missing and replaced with Matthew and Paul.

Until 1945, a picture of Christ in Glory surrounded by angels used to adorn the apse's half-cupola and to underscore the wall painting's message, while an inscription on the cornice read: "FOR GOD SO LOVED THE WORLD THAT HE GAVE HIS ONE AND ONLY SON, THAT WHOEVER BELIEVES IN HIM SHALL NOT PERISH BUT HAVE ETERNAL LIFE" (John 3:16). The apse painting thus depicted Jesus Christ as the incarnate word of God, as described by the Evangelists and witnessed by the Apostles.

Upon the construction of the dome in 1849, *Ossowsky* and *Eduard Holbein* (1807–1875) entirely renewed the apse painting in a style that matched the new iconography. *Ulrich Schneider* discovered remains of the original decoration during the restoration works performed in the 1980s, enabling him to recreate the portraits of Peter and Paul figured at the centre of the original work destroyed during the Second World War.

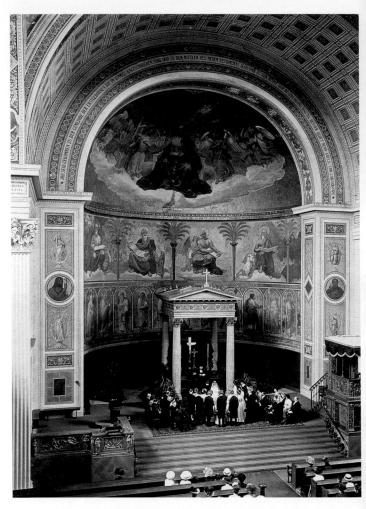

▲ *The apse with the 1850 decoration*

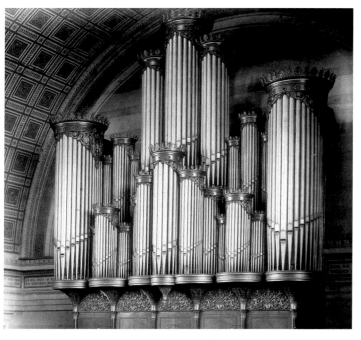

▲ *Heise great organ before 1908*

A great organ with a prospect designed by Schinkel used to stand on the south gallery. A work by Potsdam organ-builder *Gottlieb Heise* (1785–1847), the instrument had twenty-two round pipe towers topped with palmettes. Although it was intended to be much larger, it was ultimately provided with only twenty-six voices. In 1908, however, *Wilhelm Sauer* (1831–1916), an organ-builder from Frankfurt/Oder appointed to the imperial court, added orchestra bells, three manuals and forty-nine voices. The great organ was completely destroyed in 1945.

A choir organ made by *Kreienbrink Orgelmanufaktur GmbH*, a firm based in Georgsmarienhütte, Lower Saxony, has been standing to the left of the triumphal arch since 2005. The organ-builders developed

the instrument on the base of a two-manual organ that was built in Berlin in 1954 by *Karl Schuke* (1906–1987) and that Essen's Trinity parish donated to the parish of St. Nicholas. The organ-builders enlarged, retuned and remodelled the old instrument, creating an organ with a zimbelstern, twenty-one voices and a case matching the style of the interior. The parish of St. Nicholas is now looking to have a larger instrument built to suit the dimensions of the church.

Iconography

Saint Nicholas' Church used to feature an iconography of unique comprehensiveness; its destruction in 1945 is one of the most lamentable losses of the Second World War.

Everybody who enters the church instinctively looks up to the dome. Until the war, it was adorned with twenty-eight angels beneath a starry sky. The Messengers of God, including the Archangels Michael, Gabriel, Uriel and Raphael, allegorised Revelation of Divine Wisdom, Resistance to Evil, Music as a gift of God, Social Order, as well as Defence of the Word, Innocence and the Christian Faith. A dove symbolising the Holy Spirit, surrounded by winged seraphim heads, was visible on the outer dome through the four-metre-wide opaion (closed in 1981). Devoid of vertical elements, the present, greatly simplified decoration impairs the spatial impact of the drum and dome. The four restored pendentives only partly reflect the splendour of the original decoration inspired by the ideas of painter *Peter von Cornelius* (1783–1867), architect August Stüler and theologian *August Twesten* (1789–1876).

The large statues of Old Testament figures that sit in the aediculae above the fourteen drum windows suffered war damage but could be restored. The figures in this "cloud of witnesses" appear in the same succession than in the Old Testament — clockwise from the apse: Abel, Enoch, Noah, Abraham, Isaac, Jacob, Moses, Joshua, Gideon, Samuel, David, Solomon, Elijah and, directly above the apse, John the Baptist as a bridge to the New Testament. The latter owes his intermediary role to the Old Testament's last prophecy that reappears in Luke

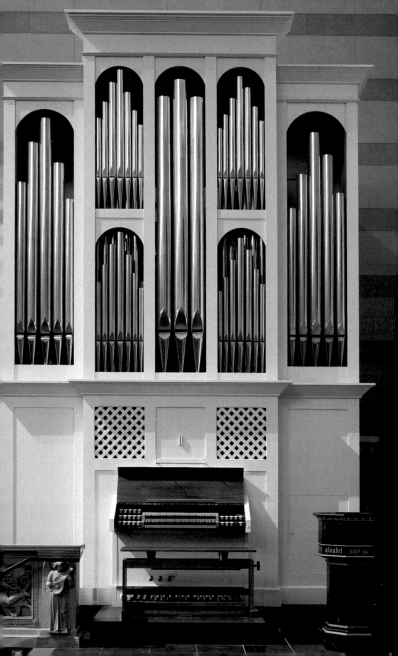

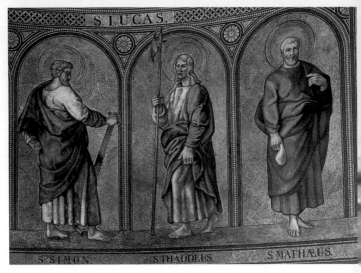

▲ *Three Apostles, apse wall painting*

1:17 ("And he will go on before the Lord, in the spirit and power of Elijah, to turn the hearts of the parents to their children").

Until 1945, a banner above the sculptures used to read: "THESE WERE ALL COMMENDED FOR THEIR FAITH, YET NONE OF THEM RECEIVED WHAT HAD BEEN PROMISED. THEREFORE, SINCE WE ARE SURROUNDED BY SUCH A GREAT CLOUD OF WITNESSES, LET US THROW OFF EVERYTHING THAT HINDERS AND THE SIN THAT SO EASILY ENTANGLES. AND LET US RUN WITH PERSEVERANCE THE RACE MARKED OUT FOR US" (Hebrews 11:39 and 12:1).

The plaster cast sculptures were made after models by pupils of *Christian Daniel Rauch* (1777–1857), one of the most outstanding Prussian sculptors: *Heinrich Berges* (1805–1852), *Adolf Bräunlich* (1805–1892), *Carl Heinrich Möller* (1802–1882), *Carl Friedrich Müller* (1812–?), *Wilhelm Rudolf Henkelmann alias Rudolf Piehl*, *Wilhelm Stürmer* (1812–1885) — and by *Christian Friedrich Tieck* (1776–1851)

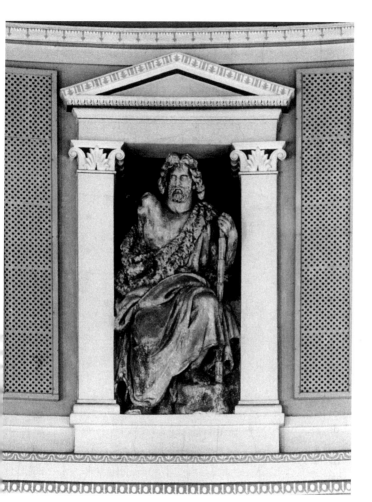

▲ *John the Baptist, statue by F. Tieck and F. X. Wittmann*

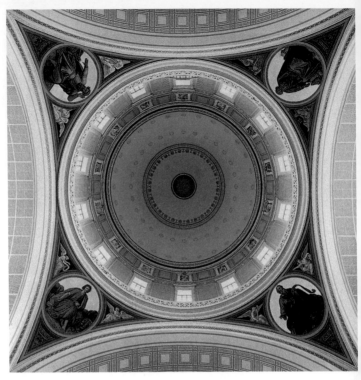

▲ *The cupola and the four pendentives*

who, like Rauch himself, was a pupil of *Gottfried Schadow* (1764–1850). Younger pupils of Rauch — *Bernhard Afinger* (1813–1882), *Theodor Dietrich* (1817–1903), *Gustav Früh*, *Hermann Wittig* (1819–1891), *Franz Xaver Wittmann* — and two Potsdam sculptors — *Wilhelm Koch* (1815–1889) and *Eduard Stützel* (1806–1877) — participated in casting the works.

Monumental medallions (3.80 metres in diameter) adorn the four pendentives. *Rainer Hauswald* restored then in 1980, whereby the two

paintings to the south had to be partially reconstructed. Figuring the **four Major Prophets** who foretold the coming of Christ, the medallions are positioned between the distant "Old Covenant" in the dome and the "New Covenant" celebrated in the choir. A banner with prophets' words chosen by August Twesten used to adorn the base of the drum and read as follows:

- "SURELY HE TOOK UP OUR PAIN AND BORE OUR SUFFERING" (Isaiah 53:4). The corresponding picture of **Isaiah** (above the pulpit, a work by *Eduard Holbein*) is flanked by an angel carrying a cross that alludes to the coming of Christ (left) and another divine messenger making offerings on the altar (right);
- "I WILL REFRESH THE WEARY AND SATISFY THE FAINT" (Jeremiah 31:25). A chained figure mourning and a second figure holding an olive branch, the symbol of hope, flank the picture of **Jeremiah** (a work by *Carl Stürmer*, 1803–1881) that represents the prophet sitting on the ruins of Jerusalem;
- "I WILL GIVE YOU A NEW HEART AND PUT A NEW SPIRIT IN YOU" (Ezekiel 36:26). The attributes of the four Evangelists (human face/Matthew, lion/Mark, bull/Luke and eagle/John) complement the portrait of **Ezekiel** (a work by *Gustav Eich*), the prophet who had a vision of the Resurrection.
- "HIS DOMINION IS AN EVERLASTING DOMINION THAT WILL NOT PASS AWAY, AND HIS KINGDOM IS ONE THAT WILL NEVER BE DESTROYED" (DANIEL 7:14). The picture of the young **Daniel** sitting next to a lion (left above the choir, a work by *Hermann Theodor Schultz*, 1816–1862) is flanked by angels carrying a garland and a palm branch, symbols of triumph over death.

Each of the extradoses, where only two parallel bands run today, were once adorned with seven **medallions** by *Rudolf Elster* (1820–1872) that figured martyrs, Church Fathers, reformers (John Wiclif, John Huss, Martin Luther, Philipp Melanchthon, Johann Calvin, Ulrich Zwingli and Nikolaus Ludwig von Zinzendorff), or the angels of the seven churches mentioned in the Book of Revelation (chapters two and

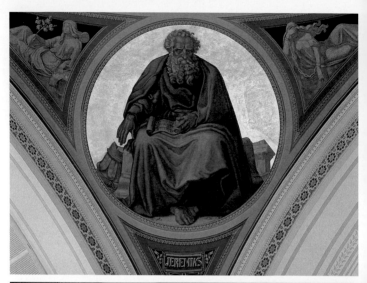

JEREMIAS

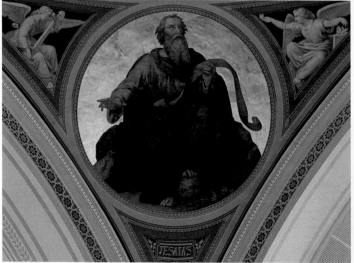

JESAIAS

▲ *The four prophet pictures in the pendentives* ▶

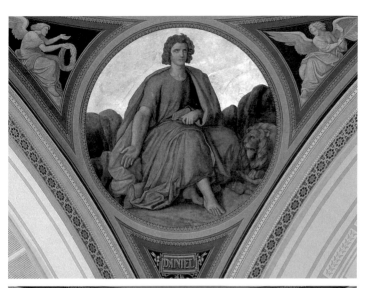

DANIEL

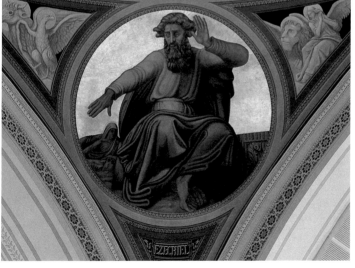

EZECHIEL

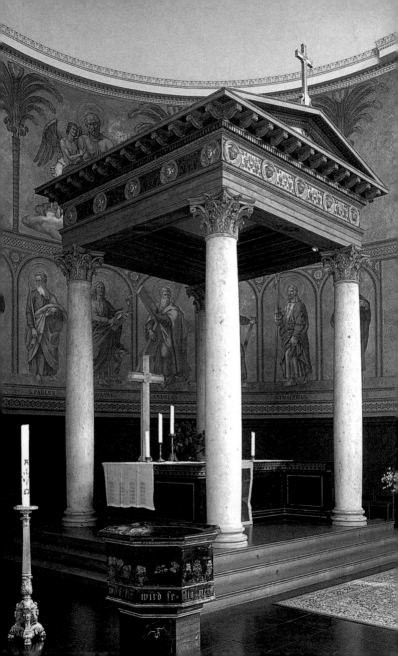

three). A handful of portraits survived the war, however. They were removed along with their plaster bases and adorn the south wall of the organ gallery.

Portraits of Paul and John the Baptist, as well as allegories of Faith, Love, Hope and Justice (all works by *Carl Stürmer*) used to adorn the piers of the **triumphal arch**. The portrait of John the Baptist, which was painted over in 1913, survived the war and likewise adorns the wall of the organ gallery.

The archivolt originally bore the words: "BUT YOU HAVE COME TO THE CHURCH OF THE FIRSTBORN, WHOSE NAMES ARE WRITTEN IN HEAVEN, AND TO JESUS THE MEDIATOR OF A NEW COVENANT, AND TO THE SPRINKLED BLOOD THAT SPEAKS A BETTER WORD THAN THE BLOOD OF ABEL". This excerpt from Hebrews 12:22–24 was replaced in 1913 by the following words: "I AM THE ALPHA AND THE OMEGA, SAYS THE LORD GOD, WHO IS, AND WHO WAS, AND WHO IS TO COME, THE ALMIGHTY" (Revelation 1:8).

Further Bible verses were once visible on the galleries and above the sacristy doors in the choir. Their sheer number illustrated that the building was a Protestant "church of words". The biblical references and their ornaments were works by the decorative painters *Bonk, Molenear* and *Lompeck*.

More than 180 **angels** adorn St. Nicholas' Church. Those visible from outside are mainly works by Ludwig Wichmann (1788–1859) dating back to 1836. Some are found on the large Diocletian cast-iron windows manufactured by the firm Egells & Woderb. The sandstone angel of peace above the main entrance door, the busts of music-playing angels on the capitals of the portico and the bas-reliefs on the panel on the main façade are also works by the same artist.

The texts within the panel refer to stucco bas-reliefs created by August Kiss in 1837 after designs by Schinkel to adorn the front and back tympanums. The relief that figured *The Sermon on the Mount* was destroyed in 1945; the one figuring *The Ascension of Christ* was removed for the construction of the dome, transferred to the Roman basilica in Trier in 1850 and also destroyed during the war.

◀ *The choir with font, Easter candlestick and ciborium* **37**

The panel above the front portico contains excerpts from the Sermon on the Mount to the left and right:

"BLESSED ARE THOSE WHO MOURN, FOR THEY WILL BE COMFORTED. BLESSED ARE THOSE WHO HUNGER AND THIRST FOR RIGHTEOUSNESS, FOR THEY WILL BE FILLED. BLESSED ARE THE MERCIFUL, FOR THEY WILL BE SHOWN MERCY. BLESSED ARE THE PURE IN HEART, FOR THEY WILL SEE GOD" (Matthew 5:4 and 6–8).

In the centre, we see excerpts from the Great Commission and Paul's warning:

"AND SURELY I AM WITH YOU ALWAYS, TO THE VERY END OF THE AGE" (Matthew 28:20); "BUT OUR CITIZENSHIP IS IN HEAVEN. AND WE EAGERLY AWAIT A SAVIOUR FROM THERE, THE LORD JESUS CHRIST" (Philippians 3:20).

The **angels of peace** atop the turrets were cast in zinc after models by August Kiss. These silent vigils are looking in all four directions, blessing and praying. Until 1945, a further seven gilt angels stood as caryatids between the columns of the lantern.

The **interior** also boasts a large number of angels, some in full-figure, for example on the pulpit and as heads on the ciborium. Zinc-cast angels singing and playing music adorn the gallery balustrades and the columns of the choir screen, while further angels float on the panels of the balustrade. Last but not least, angel faces top the gallery columns, and musician angels adorn the capitals of the crossing pilasters.

For generations, these spiritual beings have been encouraging churchgoers to join in the hymns wholeheartedly in praise and honour of God.

English version: ÜMS Berlin (Marcel Saché, Philip Brown)
Photographs: S. 16, 19, 22, 24, 25, 29: Paul-Heinrich Grönboldt, Potsdam. – p. 6, 7, 9, 15: Archive St. Nikolaikirche. – p. 11: © Kupferstichkabinett, Staatliche Museen zu Berlin. – p. 30, 31, 32, 36, back cover: Volkmar Billeb, Hoppegarten. – p. 21: Christel Köster, Potsdam. – p. 27: Archive Andreas Kitscke.
Printing: F&W Mediencenter, Kienberg
Front cover: *Saint Nicholas' Church with Potsdam University of Applied Sciences and Fortuna Gate (March 2011, Paul-Heinrich Grönboldt)*
Back cover: *musician angels on the capitals of the crossing pilasters*

Bibliography

Gustav Emil Prüfer, *Mittheilungen über den Bau der St. Nicolai-Kirche in Potsdam*, in: *Zeitschrift für Bauwesen* 2 (1852), p. 155–160, Bl. 31–33; 3 (1853), p. 3–18, 543–546, Bl. 1–4, 78, 79; Rudolf Elster: *Der Neubau der St. Nikolaikirche zu Potsdam, in Bezug auf Architektur, Sculptur und Malerei*, Potsdam 1849; Wilhelm Riehl, *St. Nikolaikirche in Potsdam*, Potsdam 1850; E. Walther, *Die St. Nikolaigemeinde in Potsdam in den Jahren 1837–1887*, Potsdam 1887; Hans Kania, *Schinkels Nikolaikirche zu Potsdam*, in: *Mitteilungen des Vereins für die Geschichte Potsdams*, N.F. 4, 1 (1904), Nr. 278; Hans Kania, *Festschrift zur Einweihung der St. Nicolaikirche zu Potsdam am Donnerstag, d. 12. Juni 1913*, Potsdam 1913; Hans Kania, *Schinkelwerk. Potsdam, Staats- und Bürgerbauten*, Berlin 1939, p. 3–60; Author unknown, *Karl Friedrich Schinkel. Sein Wirken als Architekt*, Berlin 1981 [catalogue of the exhibition "Karl Friedrich Schinkel (1781–1841)", Altes Museum, Berlin, 23 Oct. – 29 March 1981]; Andreas Kitschke/Kuratorium der Nikolaikirche, *St. Nikolaikirche Potsdam. Ein Rückblick anläßlich der Wiedereinweihung 1981*; Andreas Kitschke, *Kirchen in Potsdam*, Berlin 1983, p. 10–26 and 152; Carljürgen Gertler, *Die Nikolaikirche zu Potsdam*, in: *Das christliche Denkmal*, t. 122, Berlin 1984; Author unknown, *St. Nikolai Potsdam. 150 Jahre unter der Kuppel*, Potsdam 2000; Helmut Assing, *Die Potsdamer Burgen*, in: *Jahrbuch für Brandenburgische Landesgeschichte* 61 (2010), p. 13–39.

Files: BLHA, Rep. 2 A I, Hb. Nr. 1194; BLHA, Rep. 2 A II Potsdam Nr. 237 bis 275; BLHA, Rep. 2 Städtereg., Nr. 6417; BLHA, Rep. 19 Potsdam Nr. 3259, 3260; EZA Berlin, Rep. XVIII, Nr. 12707 bis 12710; GStA PK, I. HA, Rep. 89 (2.1.2), Nr. 23370, 23371; GStA PK, I. HA, Rep. 93 D, Nr. 2554.

Saint Nicholas' Church, Potsdam
Federal State of Brandenburg
Evangelische Kirche Berlin-Brandenburg-schlesische Oberlausitz
Evangelische St. Nikolai-Kirchengemeinde,
Am Alten Markt, 14467 Potsdam, Germany

Services: Sundays and Holidays, 10:00 a.m.

Opening hours:
January to March 9:00 a.m. to 5:00 p.m. (Sun. 11:30 a.m. to 5:00 p.m.)
April and October 10:00 a.m. to 7:00 p.m. (Sun. 11:30 a.m. to 7:00 p.m.)
May to September 9:00 a.m. to 9:00 p.m. (Sun. 11:30 a.m. to 9:00 p.m.)

Website: www.nikolaipotsdam.de

ISBN 9783422023314

9 783422 023314

DKV ART GUIDE No. 424
First English edition 2011 · ISBN 978-3-422-02331-4
© Deutscher Kunstverlag GmbH Berlin München
Nymphenburger Strasse 90e · 80636 Munich
www.dkv-kunstfuehrer.de